BP PORTRAIT AWARD 2015

National Portrait Gallery

Published in Great Britain by
National Portrait Gallery Publications
National Portrait Gallery
St Martin's Place, London WC2H 0HE

Published to accompany the BP Portrait
Award 2015, held at the National Portrait
Gallery, London, from 18 June to 20
September 2015, Scottish National Portrait
Gallery, Edinburgh, from 10 October 2015
to 28 February 2016 and Ulster Museum,
Belfast, from 11 March to 12 June 2016.

For a complete catalogue of current
publications please write to the address
above, or visit our website at
www.npg.org.uk/publications

ISBN 978 1 85514 565 8

A catalogue record for this book is
available from the British Library.

10 9 8 7 6 5 4 3 2 1

Managing Editor: Christopher Tinker
Project Editor: Andrew Roff
Design: Richard Ardagh Studio and
Anne Sørensen
Production: Ruth Müller-Wirth and
Kathleen Bloomfield
Photography: Prudence Cuming
Printed and bound in Italy
Cover: *Portrait of Esta Sexton aged 12*
by Paul P. Smith

Every purchase supports the National
Portrait Gallery, London

bp

Supported by BP

FSC
www.fsc.org
MIX
Paper from
responsible sources
FSC® C016114

CONTENTS

In my role as Acting Director I chaired the judging panel for the BP Portrait Award 2015. This year, artists were asked to submit their work digitally for the first time, an innovation that saw even more enter the competition and resulted in the highest-ever number of international entries, received from a total of ninety-two countries. Judging took place over four days, two to arrive at an initial shortlist of 456 portraits from the digital submissions and a further two for the judges to assess these paintings in their original form.

My fellow judges and I were delighted with the range of work submitted this year. The *raison d'être* of the Portrait Award – to encourage artists to focus upon, and develop, the theme of painted portraiture within their work – could be clearly seen. The portraits are always assessed anonymously – the judges have no knowledge of the artist being considered – but we recognised a strong international flavour this year. The first prize has been awarded to Matan Ben Cnaan, whose portrait *Annabelle and Guy* caught the attention of all the judges. The quality of the light in this portrait is extraordinary, as is the intensity of the gaze of all the subjects depicted – we felt there must be a story behind it.

Just as the BP Portrait Award attracts more and more international entries, it is also seen by an increasing number of overseas visitors each year. Many of these will see the work of young people who have taken part in the BP Portrait Award: Next Generation project for 14–19-year-olds, now in its sixth year and an integral part of the annual event, as indeed is the BP Travel Award, which allows any shortlisted artist to enter a proposal to travel either within the UK or internationally. The BP Portrait Award is one of the Gallery's noisiest exhibitions, as visitors have the chance to debate and discuss the portraits, and to register their own preferences using the Visitors' Choice voting facility. Younger visitors can enjoy the Family Trail, illustrated this year by Yasmeen Ismail.

The continuing support of BP, now in their twenty-sixth year of sponsorship, demonstrates a wonderful commitment to the arts. On behalf of the National Portrait Gallery I would like to express our grateful thanks to BP, and in particular to Bob Dudley, Chief Executive, to Peter Mather, Ian Adam and Des Violaris, for their enthusiasm and creative approach, as well as to other colleagues at BP for their support.

I hope you all feel as excited about this year's Award as Kim, Peter, Sarah, Simon and I did judging the entries.

Pim Baxter
Chair of the Judges,
National Portrait Gallery

SPONSOR'S FOREWORD

Welcome to the BP Portrait Award 2015. I hope you enjoy the selection of entries from this year's competition.

Each year BP's aim is to connect more artists with the competition and more people with the great work those artists create. I am pleased to say we have been able to do that again this year, no doubt helped by artists submitting their work digitally for the first time. The number of entries has increased by fifteen per cent since last year to 2,748, with a record of ninety-two countries represented, making the competition a richly international celebration of creative talent.

With so many images to view, digitisation is clearly helpful in the shortlisting process. Ultimately, however, the decisions about those works selected for exhibition and those worthy of winning are made by the judges looking at the original paintings, with all their texture, up close and in person. Last year over 400,000 people shared that very personal experience by visiting the exhibition – bringing the number of visitors to the BP Portrait Award over the twenty-five years of our sponsorship to well over 4 million.

Our partnership with the National Portrait Gallery goes from strength to strength and we thank former Director Sandy Nairne for guiding the development of the BP Portrait Award for the past twelve years. We now look forward to working with Dr Nicholas Cullinan, the Gallery's new Director, in the years to come, and our thanks go to Pim Baxter and her colleagues for overseeing a competition of such a high standard this year.

Finally, I would like to pay tribute to all the artists who submit their work: your creativity is an inspiration to so many.

Bob Dudley
Chief Executive, BP

A WILDERNESS OF MIRRORS

Neil Gaiman
Author

Who am I?

It's a fine and legitimate question, one that haunted me when I was a boy. I would stare into the bathroom mirror and do my best to answer it, teasing information from my reflection, hoping for a clue. My face would be framed by the mirror: a glass shelf with toothbrushes on it beneath my face, tiled wall and frosted glass window behind me. I had too-short dark hair, one ear that stuck out from the side of my head and one ear that didn't, hazel eyes, red lips, a sprinkling of freckles across my nose.

I would stare and stare, puzzling over who I was, and what the relationship was between who I thought I was and who I really was and the face that was staring back at me. I knew I wasn't my face. If something terrible happened to me, like a firework accident, if I lost my face and spent my life bound in bandages like a mummy in a scary film, I'd still be me, wouldn't I? I never found an answer, not one that satisfied me. But I kept asking. I suppose I still do.

That was the first question. The second was even harder to answer. It was this:

Who are we?

And to answer it, I would open the family photo album. The photographs, black and white at the front, colour in later volumes, had been carefully stuck into the family album with photo-mounts on the corners, and handwritten notes beneath each photograph identified the subjects, and where and when the photograph had been taken. Glassine, semi-transparent paper covered each page. There was something extremely formal about the photo albums. We were never permitted to play with them unsupervised, or to remove photographs. They were, when the time was right, produced by adults from high shelves or dark cupboards, only to be put away again once we had looked at them. They were not to be played with.

This is who we are, the albums said to us, *and this is the story we are telling ourselves*.

There were the dead, grave people in uncomfortable clothes, posed in black and white. There were the living, when they were so much younger as to be different people: the old people were young people then, in ill-fitting clothes and in places we could scarcely imagine. Here assembled, formal and stiff, are grandparents and great-grandparents, uncles and aunts, weddings and engagements, silver and sepia, grey and black, and then, as time moves forward, the people and the poses drift into colour and

informality, the snapshots and the holiday shots and look! You can recognise the wallpaper and you realise that the proud grandparents are holding a baby that was you, once upon a time. And now you are here again, in context, pondering your infancy, and the people who surrounded you, and the world from which you have come. Then you put down the photo album and go back to your life, reassured, given a frame and a place. The images of our forebears and our loved ones give us context, they tell us who we are.

For years, I believed I had visited the National Portrait Gallery, because I had been to the National Gallery. After all, there were portraits on the walls, were there not? It was not until I was a grown man that I finally wandered the corridors and spaces of the National Portrait Gallery and realised that I had never been there before. The embarrassment in my mistake was rapidly replaced by delight. I was glad I hadn't visited the Gallery as a boy: I would not have known who these people were, save for a handful of kings, and perhaps Shakespeare and Dickens. Now, it was like being handed an album of a family I knew too well.

Initially, I walked the galleries looking for the people I was familiar with – the ones whose stories I knew, the ones I wondered about, the ones I would have loved to have met. And then I moved wider, using the Gallery as a way of learning about people. Wondering, as I walked and as I stared, about the faces I passed: how they fit in to the history of the country, why each person was there, and not someone else in their place.

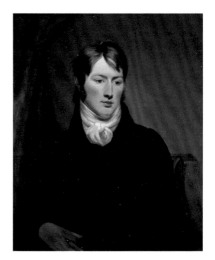

John Constable (1776–1837) by Ramsay Richard Reinagle, c.1799 (NPG 1786)
Oil on canvas, 762 x 638mm

The faces became a dialogue, the paintings become a conversation.

The National Portrait Gallery is the nation's family album, I realised. It gives us context. It is our way of describing ourselves and our past to ourselves, our way of interrogating and explaining and exploring who we are, inspecting our roots in a way that is more than just looking at the places from which we come. There is landscape, and there is portrait, after all, and they are ways of explaining the orientation of a sheet of paper, and they are the ways we understand who we are: the places we came from, the people we were.

For years I had loved Constable's landscapes: the clouds, which seemed so much more cloud-like than any clouds I had ever seen, and which forced me to stare at clouds and wonder if they were art,

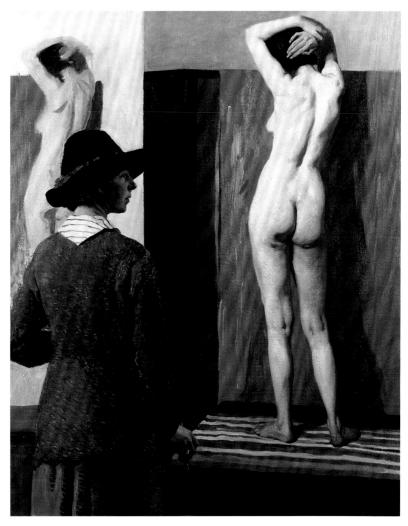

Dame Laura Knight (1877–1970) with model, Ella Louise Naper ('Self-Portrait')
by Dame Laura Knight, 1913 (NPG 4839)
Oil on canvas, 1524 x 1276mm

and the trees, and the way the sense of place gave continuity: the Suffolk landscape, which could have been my own Sussex lanes and skies. Now, for the first time, I saw John Constable: I did not expect him to be handsome, or so pensive. And there was something odd about his eyes: they seemed to be focused on different places. I wondered if he had a lazy eye, as my daughter did when she was young, or if it was simply the way that Ramsay Reinagle had presented him to us (see page 9). I imagined what it must have been like to live inside that head, to see the world, and its clouds and skies and trees through John Constable's strange eyes.

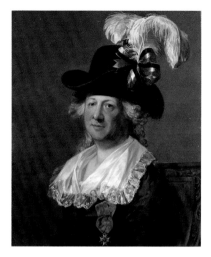

Chevalier d'Eon (1728–1810) by Thomas Stewart after Jean Laurent Mosnier, 1792 (NPG 6937)
Oil on canvas, 765 x 640mm

Some portraits were important because of who the subjects were. Others were important because of the artist. Still others were important because of the historical moment, because they were a record of their times, which are our times. Most images gain their power from the moment of intersection: painter and subject, time and history and context, ever-changing context. All come together as we walk the corridors of the National Portrait Gallery.

We look at a portrait and we begin to judge, because human beings are creatures of judgement. We judge the person being painted (a bad king? a good woman?) in the same way that we judge the artist, and occasionally we find ourselves judging them both, particularly when the subject is also the painter: Dame Laura Knight's self-portrait, a symphony in crimson and vermilion, shows the painter in perfect profile, flanked by the naked flanks of both

a model and of the painting of the model. As a woman she was forbidden to attend life-drawing classes, and here she tells us that she is a woman, and she is a master at drawing from life. The technique is remarkable, the statement powerful.

Examine the Chevalier d'Eon. I mentioned him once in a story I wrote, having vaguely meant to put him into a tale: a cross-dressing spy, caught up in intrigue, royal proclamations and court cases. Legally pronounced female, apparently against his will. I knew all this, but I did not know how kind he looked. I know that if ever I write about him, this portrait, painted by Thomas Stewart after an original by Jean-Laurent Mosnier who knew d'Eon, will change the way I tell his story.

As a writer, I find myself drawn to the writers: the Gallery's troubled portrait

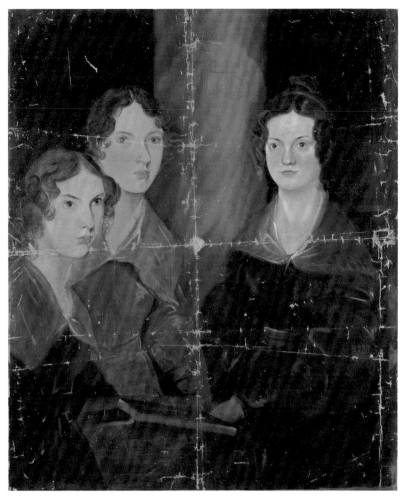

The Brontë Sisters (Anne [1820–49], Emily [1818–48], Charlotte [1816–55]
by Branwell Brontë, c.1834 (NPG 1725)
Oil on canvas, 902 x 746mm

of the Brontë sisters is like something from a mystery novel. On the left side of the painting, Anne and Emily, jaws set and defiant, on the right side the third sister, Charlotte, her face gentler, a half-smile at the edges of her lips. The three women of glorious gothic romanticism, describers of ex-wives in attics and runaways on moors; three women who wrote of haunted figures in just-as-haunted landscapes, in a portrait painted by their mysterious and dissolute brother, who was, we realise as we stare, once himself a character in the painting, the central figure around whom the three women cluster, but who is now painted out, replaced by a pillar. Still a ghostly shape confronts us, like an after-image, or a reflection. The painter's lack of skill somehow adds to the power of the picture: this is not a portrait by a professional. It is a story, frozen and mysterious, and there were, I have no doubt, tears and harsh words involved in Branwell's painting himself out of the portrait. (Or did someone else paint over him? Is the pillar some kind of clue to a mystery most gothic?)

I know that photographs tell us things about the photographer, but I do not wonder about the photographers in the same way that I wonder about the painters, even when they have composed their photographs as elegantly as any classical portrait. Julia Margaret Cameron's photograph of Alfred Tennyson, austere and wind-swept, taken on the Isle of Wight, is haunting. The background is a smudge, the hand holding a book reminds us of formal portraits of the religious, while the face is thoughtful and seems, to me at least, almost tragic. This is

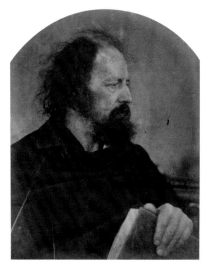

Alfred Tennyson, 1st Baron Tennyson (1809–92) by Julia Margaret Cameron, 1865 (NPG x18023) Albumen print, 255 x 200mm

the man who would write 'Crossing the Bar'.

Twilight and evening bell, and after that the Dark, I think.
And may there be no sadness of farewell, when I embark.

I learned the poem as a boy, when Death was merely an abstract idea, one I suspected I would almost certainly manage to avoid as I grew up, for I was a clever child and Death seemed quite avoidable back then.

And as we come closer to now, as we come through *modern* (and what a beautiful, old-fashioned word that is), the paintings erupt and divide into contemporary movements and ways of seeing and of describing. Strict portraiture is given to photography, then taken back once more, and now we are in my lifetime and in the

material of my life. The Brian Duffy portrait of David Bowie is as iconic as the *Aladdin Sane* record cover that I contemplated when I was twelve, certain that if I understood it, and its lightning-bolt imagery, then I would understand all the waiting secrets of the adult world. Bowie's eyes are closed on the *Aladdin Sane* cover photo, but in this image, anisocoriac eyes stare, surprised, into the flash. Bowie seems more vulnerable. And, looking at an image that once symbolised all the mysteries of adulthood for me, I realise he looks so heartbreakingly young.

The joy and power of portraiture is that it freezes us in time. Before the portrait, we were younger. After it has been created we will age or we will rot. Even Marc Quinn's chilled nightmare self-portraits in liquid silicone and blood can only preserve a specific moment in time: they cannot age and die as Quinn does and will.

Ask the question, *Who are we?* and the portraits give us answers of a sort.

We came from here, the old ones say. *These were our kings and queens, our wise ones and our fools.* We walk into the BP exhibition hall and they tell us who we are today: a confluence of artistic styles and approaches, of people we could pass in the streets. *We look like this, naked and clothed*, they tell us. *We are here, in this image, because a painter had something to say. Because we are all interesting. Because we cannot gaze into a mirror without being changed. Because we do not know who we are, but sometimes there is a light*

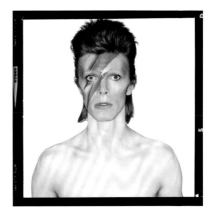

David Bowie (b.1947) by Brian Duffy, 1973
(NPG x137463)
K3 Ultrachrome print, 197 x 197mm

caught in someone's eyes, that comes close to giving us the tiniest hint of an answer.

Perhaps it is not a portrait gallery. It is, as T.S. Eliot (hanging on the wall as a modernist scrawl of overpainted profiles) put it, a wilderness of mirrors.

If you want to know who we are, then take my hand and we will walk it together, and stare into each picture and object until, finally, we begin to see ourselves.

Neil Gaiman is a bestselling author of books for adults and children. He has won numerous awards and his books have been adapted for film, television, stage and radio. Some of his most notable titles include the novels *The Graveyard Book* (2008) – the first book ever to win both the Newbery and Carnegie medals, *American Gods* (2001) and the UK's National Book Award 2013 Book of the Year, *The Ocean at the End of the Lane* (2013).

BP PORTRAIT AWARD 2015

The Portrait Award, in its thirty-sixth year at the National Portrait Gallery and its twenty-sixth year of sponsorship by BP, is an annual event aimed at encouraging young artists to focus on and develop the theme of portraiture in their work. The competition is open to everyone aged eighteen and over, in recognition of the outstanding and innovative work currently being produced by artists of all ages working in portraiture.

THE JUDGES

Chair: Pim Baxter,
Deputy Director,
National Portrait Gallery

Sarah Howgate,
Contemporary Curator,
National Portrait Gallery

Kim Mawhinney,
Head of Art, National Museums
Northern Ireland

Peter Monkman,
Artist and winner of the BP Portrait
Award 2009

Simon Schama,
Historian

Des Violaris,
Director, UK Arts & Culture, BP

THE PRIZES
The BP Portrait Awards are:

First Prize
£30,000, plus at the Gallery's discretion a commission worth £5,000.
Matan Ben Cnaan

Second Prize
£10,000
Michael Gaskell

Third Prize
£8,000
Borja Buces Renard

BP Young Artist Award
£7,000
Eleana Antonaki

PRIZEWINNING
PORTRAITS

Annabelle and Guy
Matan Ben Cnaan

Oil on board
1200 x 1300mm

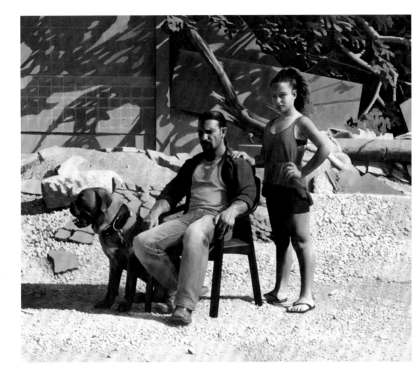

Matan Ben Cnaan's winning entry in the 2015 BP Portrait Award depicts his close friend Guy and his step-daughter Annabelle pictured near the artist's home and studio in Israel. The portrait is inspired by the Biblical story of Jephthah, transposed into a modern setting. According to the Book of Judges, Jephthah led the Israelites into battle against the Ammonites after vowing to God that, should he emerge victorious, he would sacrifice the first thing that greeted him upon his homecoming, believing this would be a dog. On his triumphant return however, it was his daughter who rushed out in welcome. Despite his horror, Jephthah kept his vow and sacrificed his only child.

'For me, historical and Biblical themes are like the mythological and religious inspirations for the Old Masters,' explains 35-year-old Ben Cnaan. 'They contain the most extreme and complex situations and moral dilemmas. Most importantly, they teach us lessons regarding human behaviour and emotions.

'Guy's story bears some parallels to the Jephthah narrative, and that made him a perfect candidate for this work,' he adds. 'Guy is a man of great determination and will, and is loved for these qualities, but these virtues come at a price. This scene is about his internal struggle between sacred faith and the secular, symbolised by his daughter and dog respectively. Guy sits torn between them.'

After developing a love for Rembrandt and Titian in his youth, Ben Cnaan obtained an MFA at the University of Haifa in 2011. He has exhibited widely in Israel, most recently at the Ha'Tahana Gallery in Tel Aviv, and his portraits and landscapes are held in private and public collections at home and abroad.

Preferring to paint in oils for the 'versatile textures and subtleties' they allow, he works mainly in his studio after making sketches and taking photographs during outdoor sittings. 'For years, the Old Masters were my inspiration, but nowadays it's classical music. The first thing I do before entering my studio is play my bouzouki and guitar for an hour, then choose a playlist according to the passage I am working on.'

A recurring presence in Ben Cnaan's work is his 'physical and artistic home' of the Jezreel Valley, a fertile plain bounded by the Nazareth mountains and the Samarian highlands. 'The light where I live knows no mercy; most of the time it is as violent as the light of an interrogation room,' he says. 'This blinding light unifies everything in the portrait of Annabelle and Guy. It plays both a pictorial and symbolic role and I chose the worst time and place to be outside.'

The background and composition also play vital roles in creating the tension of the scene. 'The rough wall and the rugged gravel echo the grittiness and grief on Guy's face, while the fig tree, casting an ominous shadow, foreshadows Annabelle's fate. The child's strong posture reflects her own resolve and her role – in both the Biblical story and in Guy's life – in carrying his burdens and misfortune.'

Interview by Richard McClure

Eliza
Michael Gaskell

Acrylic on board
370 x 270mm

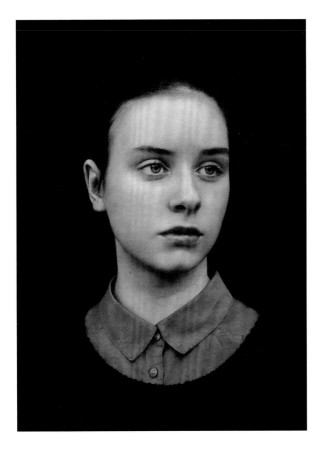

Michael Gaskell has an unparalleled record in the BP Portrait Award. Having received the second prize in the competition on three previous occasions, this year the artist has been selected as runner-up once again for a portrait of his teenage niece, Eliza.

'I try to submit portraits for the Award that exemplify everything I strive for as an artist,' explains Gaskell, who has entered six times in the last sixteen years and been chosen for exhibition on every occasion. 'I always seek simplicity and a sense of stillness. In portraiture, I like to present the subjects with little or no background, concentrate on the head and focus on the details of the face as a way of developing a sense of the individual.'

Born in 1963, Gaskell was 'the sort of child who was always painting and drawing'. He studied at St Helen's College of Art and Design and Coventry Polytechnic, now lives in Leicester, and has been a full-time painter for more than twenty years. His work has been exhibited in five solo London shows and numerous group shows across the UK.

His sitters range from family members to complete strangers he sees on the street. 'I see something in someone, a look, most often it's fleeting and seems barely perceptible, but it triggers something in me and then the entire painting process seems like an attempt to re-find it.'

Until eighteen months ago he painted exclusively in egg tempera on board, but looking for a fresh challenge decided to try a new media, acrylic. 'I found the transition quite difficult,' he admits. 'I spent just over a year teaching myself how to think and work differently. This painting of Eliza is one of the first completed paintings that I think has the same qualities as my other work.'

Gaskell numbers Rembrandt's Kenwood self-portrait and Antonella's *Portrait of a Man* among the paintings he most admires. For his portrait of Eliza, the primary influence was the lighting and composition characteristic of the fifteenth-century painter Hans Memling, whom he had recently studied after being commissioned to make a painting of an American collector who had a particular interest in Memling.

Gaskell began his portrait of Eliza by making drawings, measuring proportions and taking photographs. 'I don't start a portrait immediately. I like to give myself time to reflect before I begin. Once the portrait's composition is set, I work intensively over a few weeks. Then I set it aside – sometimes for months – before I rework it.'

In this instance, he completed the portrait over a period of a year. 'I hope the painting conveys a sense of Eliza's growing confidence as she develops into a woman, but retains some of the self-consciousness, which was also present at the time,' he says. 'This period of adolescence passes so quickly, but there are moments that hang there fleetingly that hold a feeling of the child, but also contain a glimpse of the adult. I hope the portrait has a sense of this.'

Interview by Richard McClure

My Mother and my Brother
on a Sunday Evening
Borja Buces Renard

Oil on canvas
1500 x 2000mm

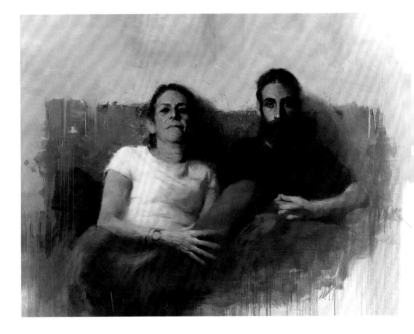

Borja Buces Renard was born in 1978 and grew up in Madrid 'surrounded by canvases and Old Master paintings'. Both his parents worked restoring masterpieces for the major art collections and museums in Spain. 'Most of my family lived and breathed art,' he says. 'That made it easy for me to fall in love with painting.'

Since graduating from the University of Madrid, he has worked as a figurative artist for fifteen years, recently dividing his time between Spain and Florida. 'I don't want to be known just as a portrait artist, but I believe that an artist should paint the world that surrounds him, the things that he knows really well, in order to create honest and meaningful art,' he says. 'For me, my family is my inspiration. They are the most important thing in my life, so they will always be part of my art-making process.'

His third-place entry in the 2015 BP Portrait Award is a study of his mother Paloma and brother Jaime in the living room of the family home, where they traditionally spend Sunday evenings, talking about art and exchanging news.

'For the past four years my father suffered from some kind of multiple sclerosis that debilitated him progressively. Over the past year he was so sick that he was unable to join us for our Sunday evening discussions. The image shows my father's absence and that difficult time for all of us, especially for my mother who had dedicated herself to taking care of him. Knowing that my father was going to pass away was hard on all of us. I tried to represent this moment.' Buces began by making sketches and taking photographs. The portrait was completed over seven months and several sittings. 'I had painted my mother, father and brother many other times on that same couch, so I was pretty sure about how I wanted to use the light and colour,' he recalls. 'I wanted to focus the viewer's attention on their faces, taking away importance from the background.'

The process of painting the faces took repeated sittings, with Buces erasing part of the last session's dried layer of oil paint using a palette knife or sandpaper, before painting over it again and again until satisfied with the result. 'The technique that I use was not taught to me by any teacher. It is the result of different techniques that I have experimented with throughout the years. It creates a non-static image, something atmospheric. It makes the canvas come alive and reveals the different emotions the sitters are going through.'

Sadly, a few weeks after the painting was finished, his father died. 'The most important thing for me is transferring my emotions to the canvas, linking them to the sitter and transmitting everything to the viewer,' he concludes. 'In my opinion, this painting marks an inflection point in my art; it is the most sincere work I have ever made.'

Interview by Richard McClure

J.
Eleana Antonaki

Oil on canvas
1450 x 1450mm

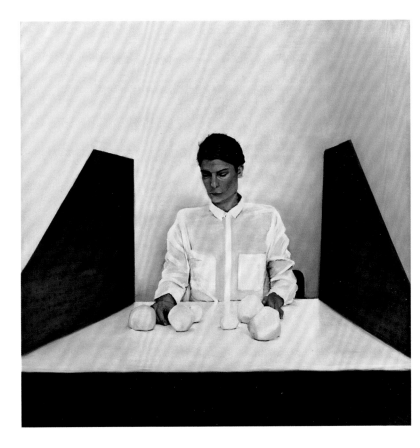

The BP Young Artist Award goes to Eleana Antonaki for her portrait of Julie Laenkholm, a close friend and fellow artist. Julie is pictured meditating in her New York studio. Placed before her, on her working table, are some of the sculptural objects she uses in her art works.

'Julie works mainly with sculptures, which she incorporates into her installations, performance and video pieces,' says Antonaki. 'Her art explores the idea of everyday objects as things that have some kind of agency on the human body. I am fascinated by the connection she develops with her sculptural objects and the almost ritualistic and obsessive way she treats objects of "low value" like plastic bags and balls of clay.'

Antonaki was born in Volos, Greece, in 1989 and drew her early creative inspiration from helping her mother and grandmother home crafting. Even today she uses embroidery in her work. She received a BFA from the University of Ioannina before moving to New York where she is currently studying for her MFA at Parsons School of Design. She works across a range of media, but considers herself 'primarily a painter' and tackles such subject matter as the human body and its deterioration, feminine beauty and sexuality.

For the portrait of Julie, Antonaki was interested in composing an austere environment that reveals little about the space in which the sitter exists, while also suggesting a narrative that takes place somewhere 'outside of the image', either before or after the depicted moment.

'I don't do portraits very often; my personal research on painting rarely lends itself to the subject. But I enjoyed painting Julie, and I think the context of the BP Portrait Award gave me an incentive to explore portraiture in my practice without the pressure of having to tie it into a previous body of work.'

All of Antonaki's paintings are oil on canvas, which, she says, allows her 'the effect of transparency', while the slowness of the paint provides time to build up details gradually. Typically, she begins each work with reference photographs and watercolour sketches to help her decide on the final image. She then begins the painting by drawing on a prepared canvas before building the image in layers. 'I work in a very traditional way, I suppose,' she says. 'I consider photographs to be sketches for paintings, so I don't have to deal with a constantly changing image all the time. I can manipulate the image into what I want it to look like.'

Her latest work incorporates painting with video and other media, part of her ongoing research into ways in which traditional painting can remain relevant today.

'I am interested in what it means to work with traditional painting in a post-conceptual contemporary art context,' she says. 'Traditional painting is still relevant. However, the challenge for a painter is to find ways of engaging with contemporary concerns of art, and that may mean taking up issues or strategies that are avant-garde. A lot of the work I'm doing revolves around this.'

Interview by Richard McClure

SELECTED
PORTRAITS

Natalia
Jorge Abbad-Jaime
de Aragón

Oil on canvas
1460 x 1140mm

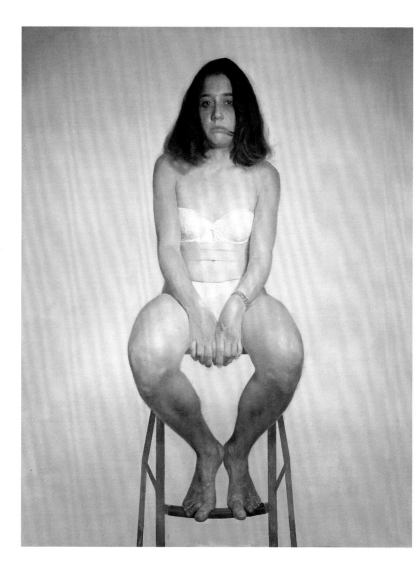

Family Portrait
Salvador Antúnez del Cerro

Oil on wooden board
810 x 750mm

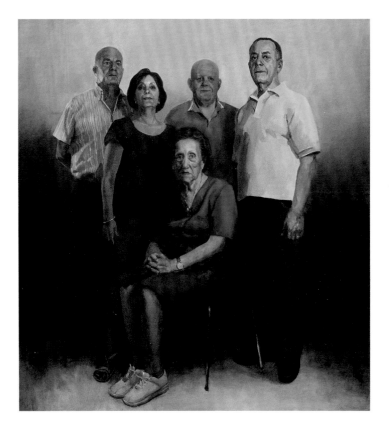

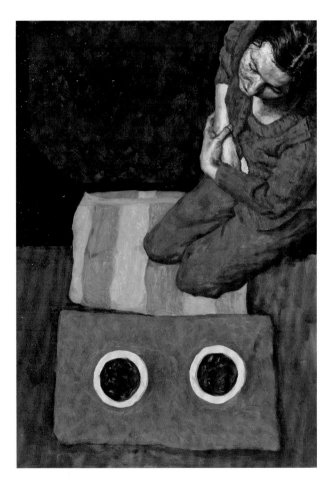

Fuck Mondays
Nathalie Beauvillain Scott

Oil on canvas
860 x 1010mm

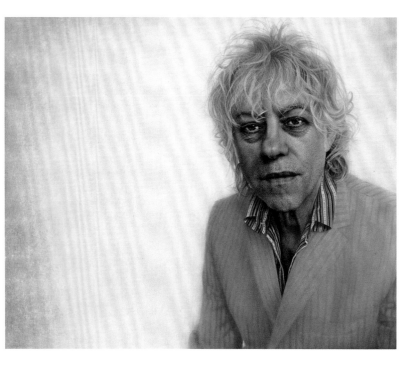

Rebekkah
Sara Berman

Oil on canvas
585 x 485mm

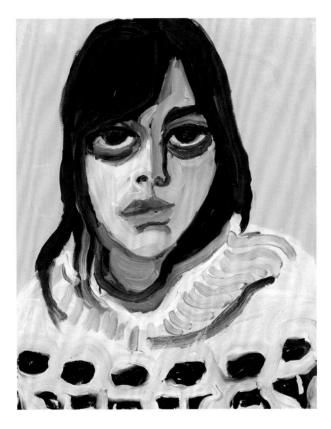

Nana
Maud C. Bryt

Oil on canvas
1524 x 1168mm

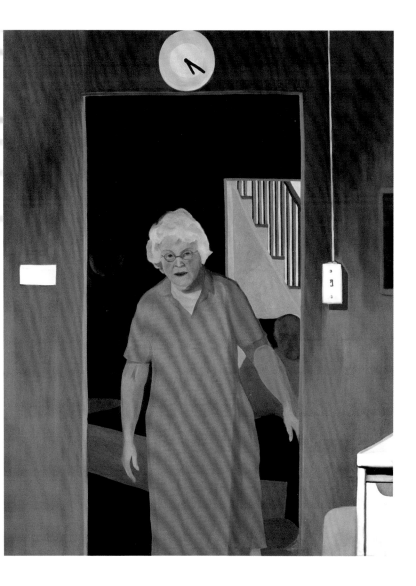

Simon
Steve Caldwell

Acrylic on board
500 x 400mm

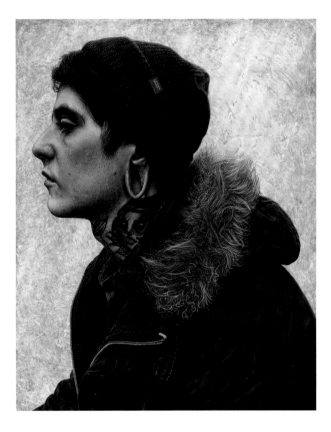

The Red Chair
Maria Carbonell

Oil on board
1500 x 1500mm

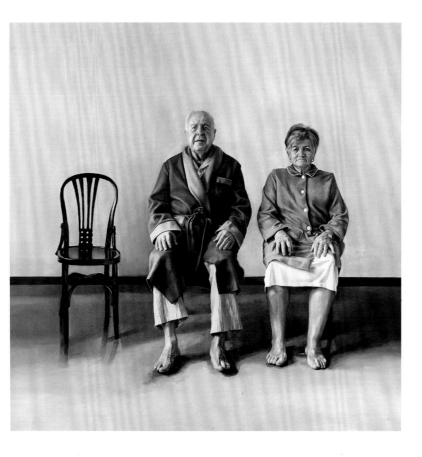

Father and Son
Kelly Carmody

Oil on linen
1778 x 1320mm

Self-Portrait
Comhghall Casey

Oil on aluminium
350 x 280mm

Self-Portrait
Jorge Castillejo Striano

Oil on canvas
610 x 407mm

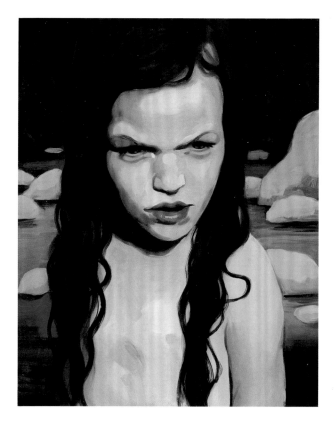

Juanito
José Luis Corella

Oil on board
1000 x 1000mm

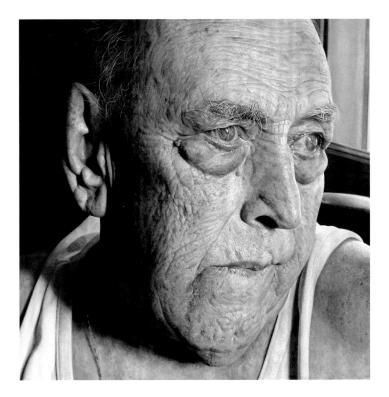

Back Portrait no.8
Daniel Coves

Oil on linen
1900 x 1900mm

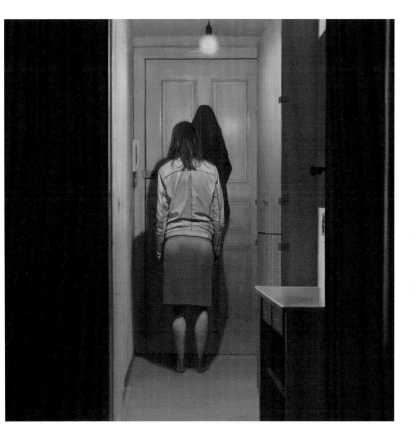

Sink or Swim
Ian Cumberland

Oil on linen
1000 x 1500mm

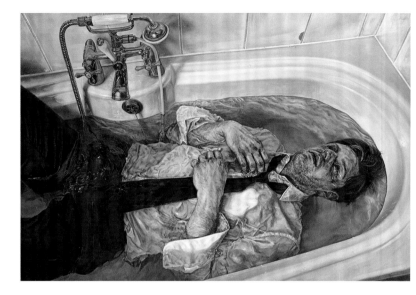

Ordeal
Murat Tezcan Demirbas

Oil on canvas
1500 x 1500mm

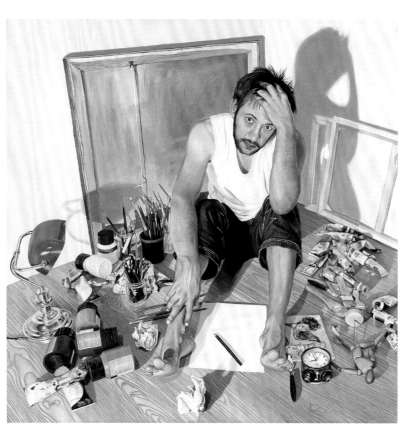

Sean Arrives
Stephen Durnin

Oil on canvas
508 x 762mm

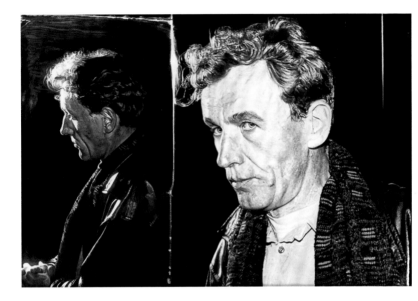

Parotia
Robert Fawcett

Oil on board
295 x 240mm

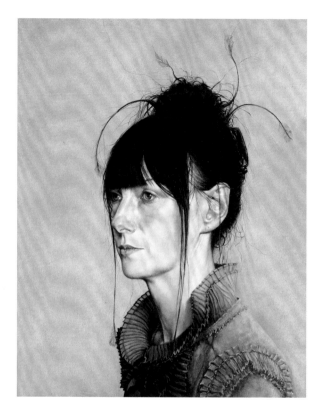

Hamish & Sophie Forsyth
Nancy Fletcher

Oil on canvas
560 x 487mm each

 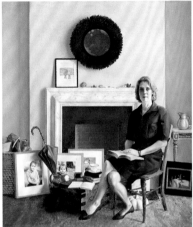

Self-Portrait, Melting Point 2015
Felicia Forte

Oil on panel
508 x 508mm

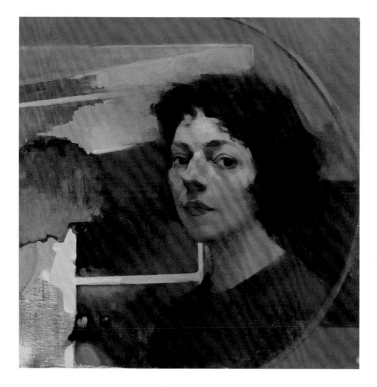

The Reader
Raoof Haghighi

Oil on canvas board
500 x 700mm

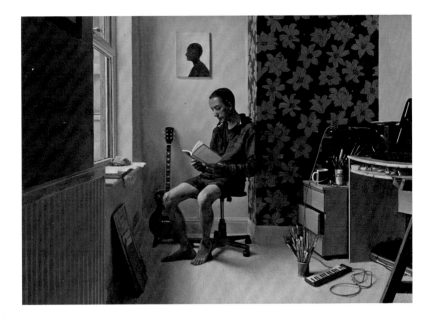

Mr L. at his Post in a Dementia Ward; Oil on wooden panel
Amsterdam or; 'Shall We Marry?' 380 x 340mm
Raymond Huisman

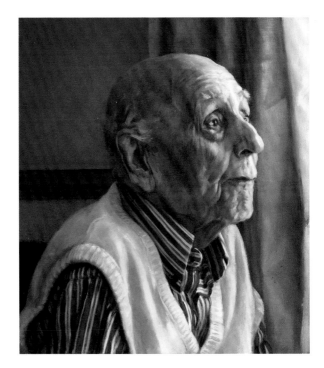

The History Men:
Dr Thomas Rohkrämer and Dr Kay
Schiller
Milan Ivanič

Acrylic on canvas
500 x 600mm

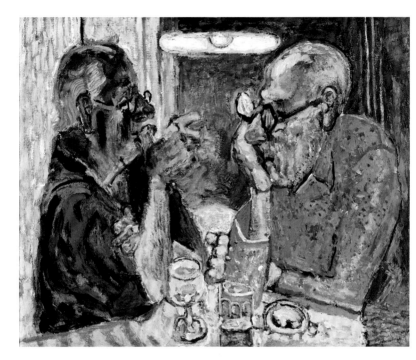

Under the Clootie Tree
Lyndsey Jameson

Oil on linen
710 x 560mm

Abu Muhammad: A Palestinian Worker
Irina Karkabi

Oil on canvas
400 x 300mm

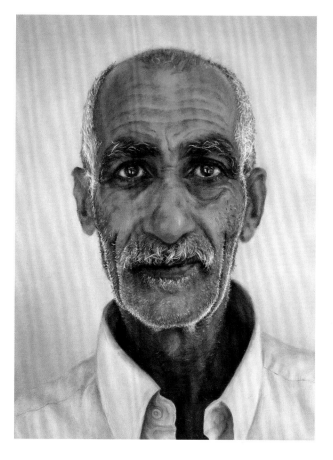

Portrait of Sam Goldofsky,
Survivor of Auschwitz
David Jon Kassan

Oil on acrylic mirror
410 x 270mm

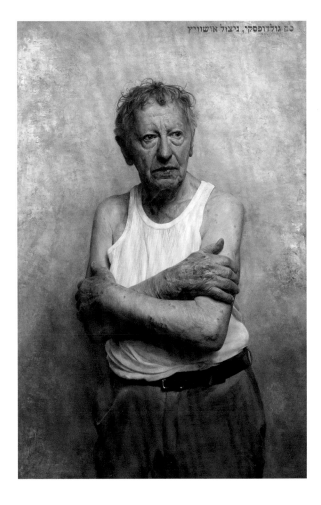

Genesis
Jerome Lagarrigue

Oil on linen
2500 x 2000mm

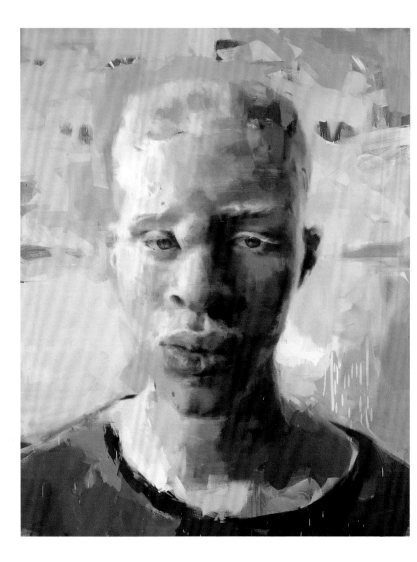

The View in Winter
David Lawton

Oil on board
260 x 210mm

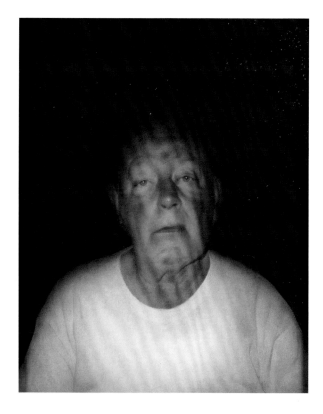

This
Gavan McCullough

Oil on canvas
700 x 600mm

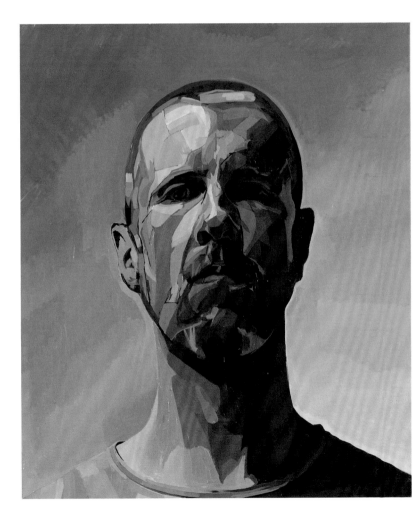

Oil on board
400 x 280mm

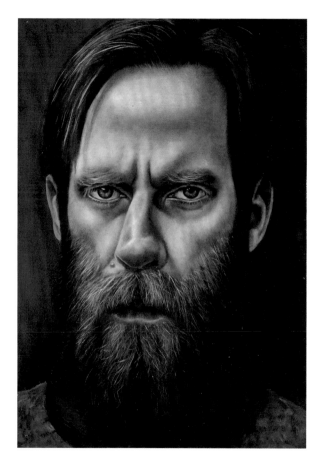

How Soon is Now? (Self)
Alan McGowan

Oil on panel
1220 x 810mm

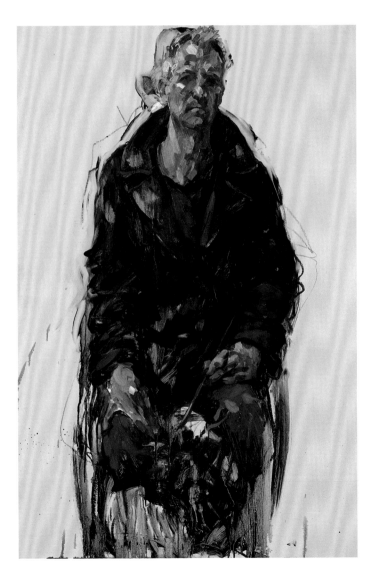

Sebastian
Jan Mikulka

Oil on canvas
700 x 1000mm

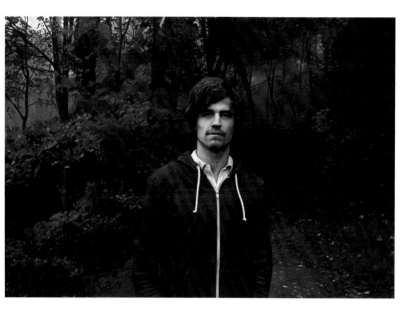

Rocío. Desnudo sobre alfombra
(Rocío. Nude on Carpet)
Eduardo Millán

Oil on linen
1380 x 900mm

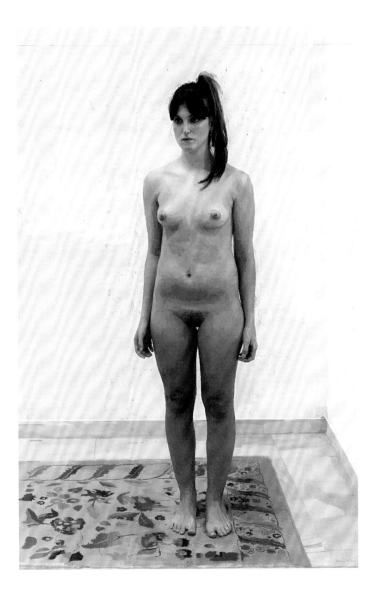

Elizabeth (2015)
Nashunmenghe

Oil on canvas
330 x 250mm

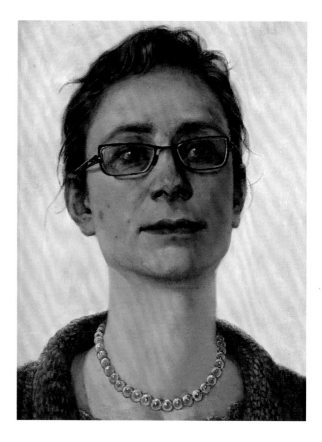

My Mother, My Sister
Grace O'Connor

Oil on wood
225 x 225mm

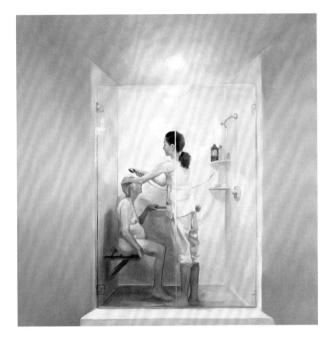

The Convalescent
Helen O'Sullivan-Tyrrell

Oil on canvas
400 x 500mm

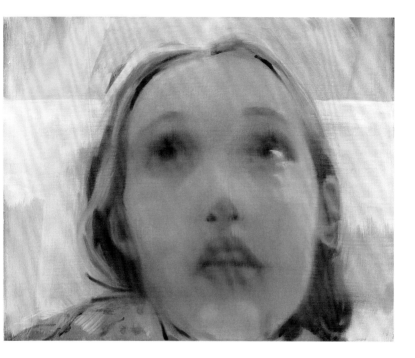

What Now
Rebecca Orcutt

Oil on canvas
610 x 1220mm

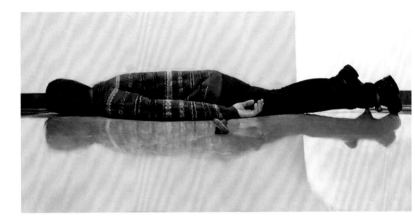

Clarity
Frank Oriti

Oil on panel
609 x 609mm

The Cynic
Tristan Pigott

Oil on linen
255 x 205mm

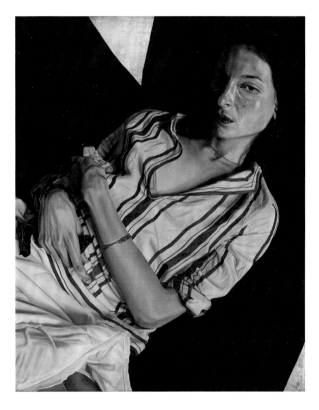

Happy Melancholy
van Rerat

Acrylic on canvas
1000 x 1000mm

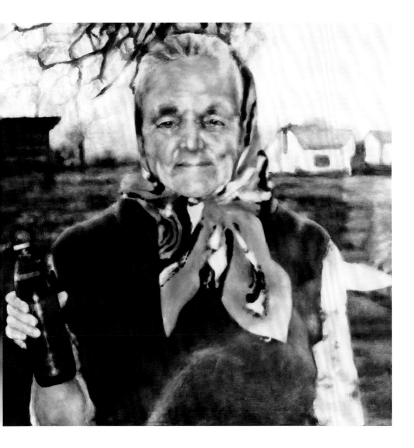

Anwen
Anne-Christine Roda

Oil on linen
1300 x 970mm

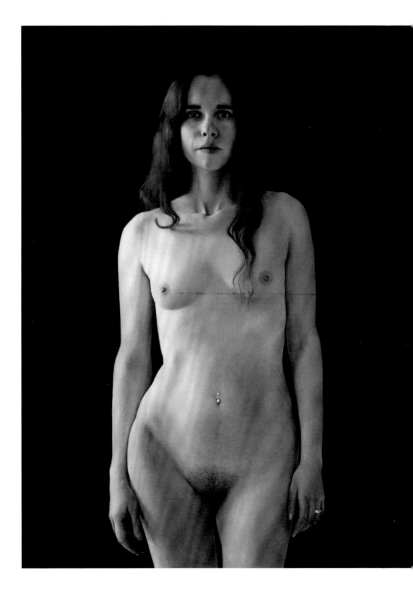

A portrait of Ben the Masseur
Lee Myles Simmonds

Oil on canvas
1220 x 765mm

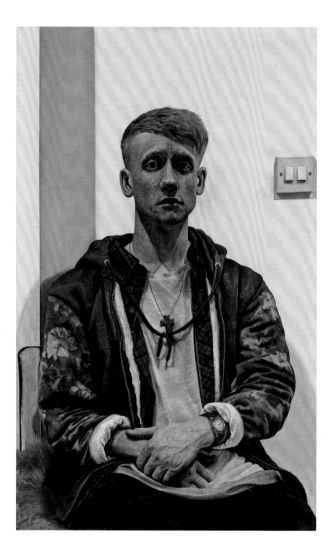

Portrait of Esta Sexton aged 12
Paul P. Smith

Oil on linen
705 x 558mm

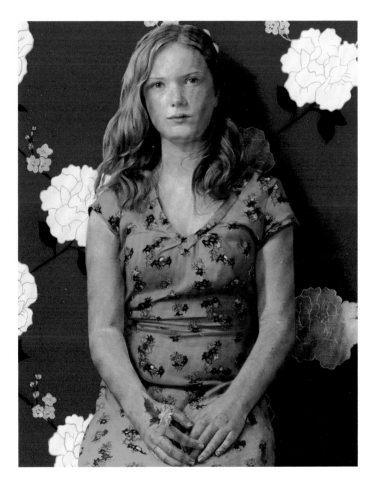

Oil on panel
304 x 304mm

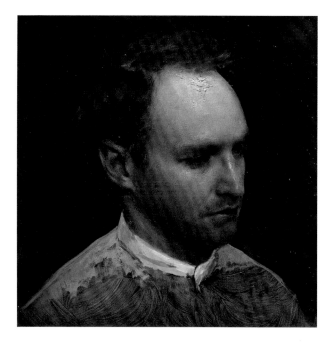

Ugly – Portrait of Robert Hoge
Nick Stathopoulos

Acrylic and oil on linen
1370 x 1370mm

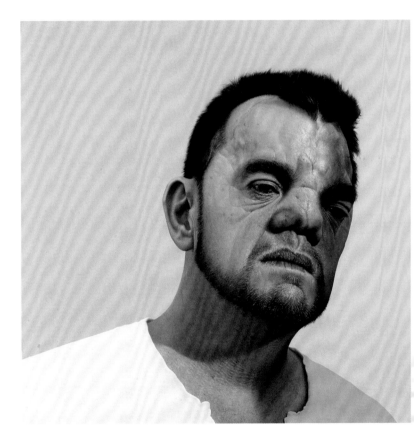

Julian Bingley
Benjamin Sullivan

Oil on linen
762 x 504mm

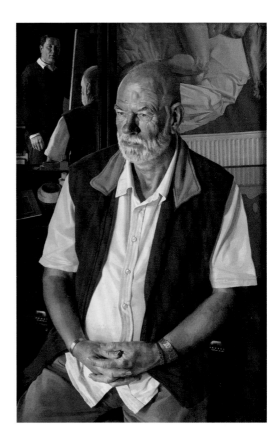

A Silent and Inconsequential Victory
Dani Trew

Oil on board
700 x 500mm

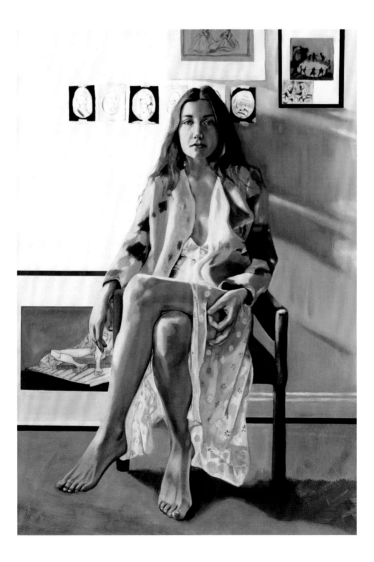

Portrait of Christian in Profile
Marco Ventura

Oil on gesso panel
310 x 230mm

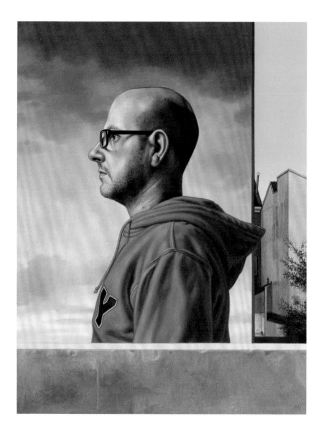

Charlotte and Emily
Leslie Watts

Egg tempera on clayboard
500 x 400mm each

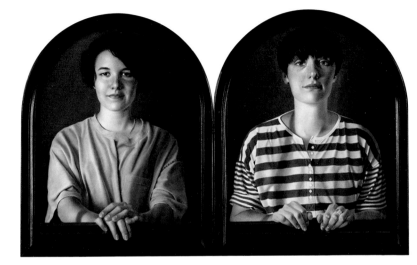

Figure Lying by Water
Antony Williams

Egg tempera on board
1370 x 1150mm

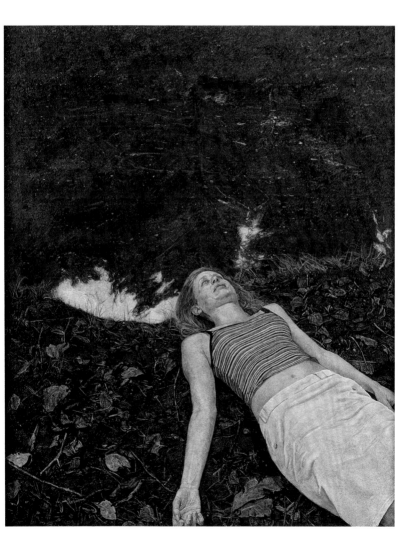

Just After Noon
Sophie Williams

Oil on board
610 x 1220mm

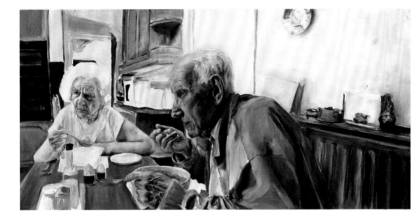

BP TRAVEL AWARD 2014

Each year exhibitors are invited to submit a proposal for the BP Travel Award. The aim of this award is to give an artist the opportunity to experience working in a different environment, in Britain or abroad, on a project related to portraiture. The artist's work is then shown as part of the following year's BP Portrait Award exhibition and tour.

THE JUDGES

Sarah Howgate,
Contemporary Curator,
National Portrait Gallery

Susanne du Toit,
Artist

Des Violaris,
Director, UK Arts & Culture, BP

The Prizewinner 2014
Edward Sutcliffe, who received £6,000 for his proposal to travel to Los Angeles.

CRICKET OUTTA COMPTON

Edward Sutcliffe

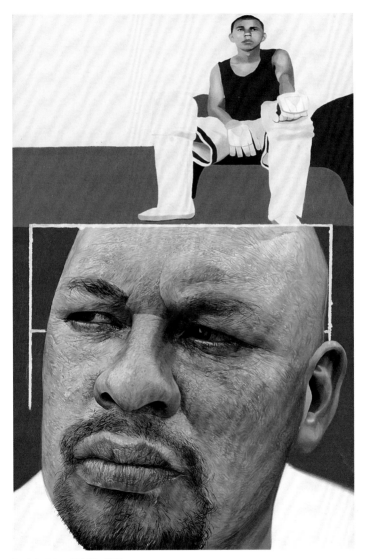

Sergio by Edward Sutcliffe, 2014
Oil on canvas, 450 x 300mm

Edward Sutcliffe was listening to the radio while working in his studio two years ago when his attention was caught by a short report on Compton Cricket Club, a unique outpost of the sport based in the unlikely location of south Los Angeles, one of the most crime-ridden areas in the United States. As a keen cricketer in his youth, and bemused by the notion of a group of mainly black and Mexican teenagers discovering and falling for the quintessentially English game, Sutcliffe was sufficiently intrigued to propose a series of portraits of the Compton cricketers for the 2014 BP Travel Award.

'I love meeting the people I paint; it really is one of the best parts of my job,' says Sutcliffe, who has been shortlisted for the BP Travel Award on two previous occasions. 'If you work as a portrait painter you have got to like people, and I carry some unforgettable memories of the sitters I have met. A good relationship between artist and sitter will give the final work chemistry, energy and soul.'

Compton Cricket Club was established in 1995 by homelessness activist Ted Hayes and British movie producer Katy Haber as an initiative to get disadvantaged youngsters off the streets of Compton, where gang-related violence, particularly between the rivals Bloods and Crips, was claiming around 100 lives every year.

According to the club's mission statement, its goal is 'to curb the negative effects of gang activities and encourage civility and good citizenship'. In the twenty years since its formation, the club has maintained the core members from its early days while continuing to attract local youth. Affectionately known as the Homies and the Popz, the club has toured Ireland, Australia and England, even taking tea at Buckingham Palace.

'It was formed at the height of the crack epidemic during the 1990s,' says Sutcliffe. 'The club gave the players a sense of community and togetherness that was so lacking in the neighbourhoods where they lived. That principle continues to this day.'

Born in Walsall in 1978, Sutcliffe studied art with art history at the University of Wales, Aberystwyth, and took a post-graduate diploma at Central Saint Martins, London. He is now based in London and Dubai. His paintings have been selected for exhibition in the BP Portrait Award on seven occasions, and typically fall into two categories: hyper-realist paintings of family and loved ones, and more conceptual portraits, including one of a Prince Charles lookalike. In his 2014 entry, he

Danny by Edward Sutcliffe, 2014
Oil on canvas, 205 x 153mm

explored the idea of mimicry by painting the art forger John Myatt and then commissioning Chinese artist Li Wu Da to paint a distorted mirror image of the portrait at the foot of the panel.

'The paintings of people close to me have included my girlfriend, now wife, my brother and even my local MP at the time, Glenda Jackson – they aim to be personal and intimate,' he explains. 'The second type have an idea as a starting point. I am interested in exploring tensions between creativity and copying and how these qualities that may seem mutually exclusive can exist in the same painting.'

For his Compton project, Sutcliffe decided on a much more narrative-driven body of work. 'The amazing story of the players was the single thing I wanted to get across in the

paintings. I guess I wanted to make pure and honest portraits of the guys unhindered by too much concept or cleverness.'

Upon arrival in Los Angeles, he was made welcome by a team barbecue. Having already familiarised himself with potential sitters through online articles and documentaries, Sutcliffe explained to the players what the project would entail.

'The club has had a fair amount of media coverage, and that helped me form an image in my head of the people that I would be meeting and the possible works that might come from it,' he says. 'Knowing that many of the players had experienced very difficult upbringings made me think that I might have to deal with some demanding characters, but choosing each sitter wasn't difficult.'

Sutcliffe met around twelve members of the squad and completed portraits of its key figures, including founders Ted and Katy. The sittings were organised into individual sessions, usually lasting around three hours at the players' houses, where Sutcliffe worked out the composition, made sketches and took reference photographs. Each portrait was then painted in oils upon his return to the UK.

'Oil paint is a real buttery joy to work with especially when you are trying to depict skin tones and features,' he explains. 'Willem de Kooning said "Flesh was the reason oil paint was invented." I agree with him wholeheartedly. I haven't yet found

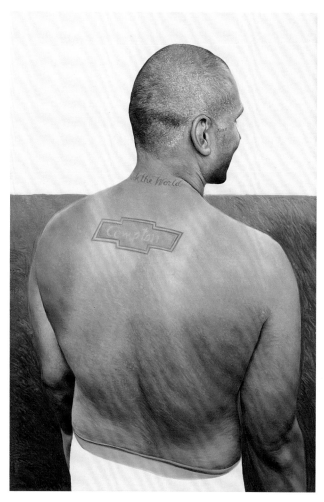

Steve by Edward Sutcliffe, 2014
Oil on canvas, 420 x 280mm

anything that does the job better.'
Two of Sutcliffe's sitters, Steve and
Ricardo, had both spent time in
prison for various misdemeanours.
As a result, their bodies are covered
with crudely inked tattoos of gang
symbols and territorial markings,
which became prominent features
in their portraits.

'Steve's tattoos are signs of the
difficulties that growing up in
Compton can bring. I painted him
from the back where the struggles
and frustrations are inked into his skin
– the words 'fuck the world' staring at
the viewer. To give the portrait warmth,
his head is turned where you can just
see the start of a smile.

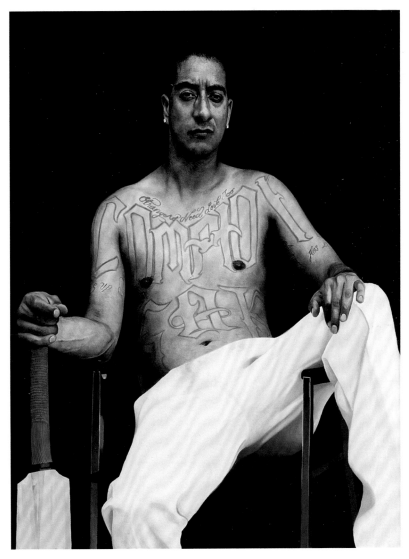

Ricardo by Edward Sutcliffe, 2014
Oil on canvas, 1189 x 900mm

Ted by Edward Sutcliffe, 2014
Oil on canvas, 230 x 205mm

'With the portrait of Ricardo, I wanted to combine the tattoos, those visual aspects of his presence, with a rather regal and traditional portrait – one that you might see at the MCC or even in the upstairs galleries of the National Portrait Gallery. It's an ambitious portrait and seems to encapsulate what Compton Cricket Club is about.'

Another sitter, Danny (see page 82), had also gone from dodging bullets to dodging bouncers. He'd experienced a troubled upbringing until the club had provided him with stability and a sense of belonging to a community. Here, the artist used the canvas to illustrate how the club was 'literally patching him up and gluing him together'.

Faced with a tight deadline, Sutcliffe was forced to change his usual working methods, mixing larger canvases with some smaller studies. 'When you paint in a hyper-realist fashion it's always going to be a challenge to get a body of work ready in six or seven months. My works are labour intensive and I realised that with the short amount of time I had, some works needed to be small to allow me to complete the bigger paintings and it just flowed from there.

'There were many late nights of painting but in the end I am satisfied with the results. I hope the paintings tell the story of these amazing people.'

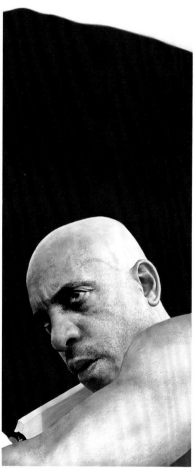

Katy by Edward Sutcliffe, 2014
Oil on canvas, 205 x 153mm

Theo by Edward Sutcliffe, 2014
Oil on canvas, 1005 x 400mm

Many congratulations are offered to all the artists selected for the exhibition, and especially to the prizewinners, Matan Ben Cnaan, Michael Gaskell and Borja Buces Renard, and to Eleana Antonaki, the winner of the prize for a younger painter. I am also extremely grateful to all the artists who put so much effort into creating their work and entering the 2015 competition.

Very special thanks go to my fellow judges: Sarah Howgate, Kim Mawhinney, Peter Monkman, Simon Schama and Des Violaris, who were a delight to work with. Their thoughtful and knowledgeable observations, our energetic discussions and their respect for each other's opinions made the judging process a pleasure to chair. I am also grateful to the judges of the BP Travel Award: Sarah Howgate, Peter Monkman and Des Violaris. My thanks go to Neil Gaiman for his wonderful catalogue essay, which reminds us, touchingly, that the images in the National Portrait Gallery's Collection form the 'nation's family album'. I would particularly like to thank Clementine Williamson for her overall management of the 2015 BP Portrait Award exhibition, brilliantly assisted by Michael Barrett, and my colleague Sarah Tinsley for all her support. I am very grateful to Andrew Roff and Richard McClure for their editorial work, Richard Ardagh Studio and Anne Sørensen for designing the catalogue. My thanks also go to Alice

Bell, Rosie Broadley, Nick Budden, Harry Byrne, Robert Carr-Archer, Jane Chambers, Neil Evans, Tanja Ganjar, Ian Gardner, Maddie Gibson, Justine McLisky, Ruth Müller-Wirth, Nicola Saunders, Fiona Smith, Liz Smith, Christopher Tinker, our Visitor Services' staff, and many other colleagues at the National Portrait Gallery for all their hard work in making the competition and exhibition such a continuing success. I am always impressed by the extremely efficient management of the selection and judging process by The White Wall Company, and this year I would like to add thanks to David Saywell and Emanuel De Freitas, as well as Matt Chapman, Stephen Norris and Louise Rawlinson from Cogapp who put so much work into creating the technical side of the digital judging, and ensuring that it ran smoothly.

Pim Baxter
Deputy Director,
National Portrait Gallery

INDEX